KENT

Sansibar

Because he turns his back
He loses
Over the chimneys
Little red corners
Little red vixen
All live in loneliness
They endure the longest
They eat their fur 1933

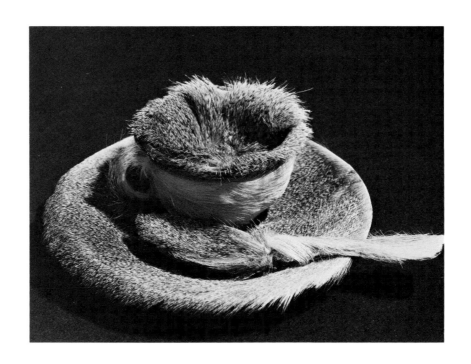

MERET
OPPENHEIM

9 March through 9 April 1988

41 East 57 Street New York, NY 10022 Tel 212 980 9696 Fax 212 421 5368

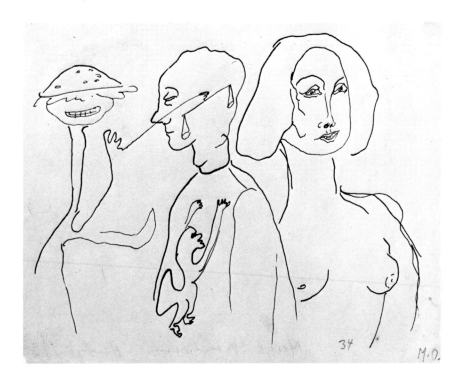

1
Woman with Naked Upper Part of the Body. Man with Balance Over the Ear. Two Ghosts 1936—37

THE CONTINUING PRESENCE OF MERET OPPENHEIM
Bice Curiger

When comprehensive retrospectives of Meret Oppenheim's work were first mounted by European museums in the 70s, the public was astonished by the richness and regenerative impact of her art, by its display of unity within multiplicity, permanence within change. But it is the work of younger artists that has since facilitated access to Meret Oppenheim's oeuvre. Significantly, interest has not been confined to any specific (historical) period, to a clearly defined achievement completed in the past, but to both early and late work, the latter following an utterly unpredictable course. Thus, as of the late 70s, galleries ordinarily reserved for the very latest developments in art began showing her work (Marian Goodman Gallery, New York; Galerie Nächst St. Stephan, Vienna; Galeria Pieroni in Rome, the ARC in Paris and Documenta 7, 1982, in Kassel). The approach to Meret Oppenheim had been out of focus far too long. She was already in her 60s when she finally began to receive long overdue and well-deserved acclaim.

The culprit is in part her fur-covered cup and saucer, an object created in 1936 and titled "Déjeuner en Fourrure" ("Breakfast in Fur"), which has been prominently displayed by the Museum of Modern Art for over 50 years and is currently one of the most cited works of Surrealist art. When Alfred Barr, Jr. bought the object along with several other Surrealist pieces from the Cahier d'Art gallery in Paris, Meret Oppenheim was just 23 years old. It was the time when she and her much older colleagues contributed to exhibitions of Surrealist art in Paris, Copenhagen,

London and New York, after Hans Arp and Alberto Giacometti had invited her to participate in the "Salon des Surindépendants."

Meret Oppenheim had come to Paris from Basle in 1932 to study at the Académie de la Grande Chaumière. There she attended courses only sporadically, preferring to work on her own. During this period, up to 1939, she produced drawings, collages, pictures, objects and exceedingly beautiful poems. These early works are signals of a time marked by great sensitivity and clarity during which she zeroed in on fundamentals with the unerring self-assurance of a sleep-walker, uncovering the artistic issues that were to be her vital concern for years to come. This vehement perception of standing-in-the-world is perhaps the specific privilege of tender age, but it also reveals the fact that from the start Meret Oppenheim's work was defined and motivated by personal content. This also explains why, although influenced by other artists, she was never constrained to copy another position.

Looking back, it is still incredible to think that such a young person succeeded in joining the Parisian circle of celebrated artistic innovators, all 15 to 25 years older than she was. Meret Oppenheim's intelligence, her cultivation, her quest for freedom, her caprice and her supreme beauty, immortalized in Man Ray's photography, all shared in turning her into a legend. In consequence, evaluations of her work in subsequent decades failed to recognize the extraordinarily independent character of Meret Oppenheim's creativity. The greatest artistic influence exercised on her

in Paris was the corroboration of her outlook on life.

Meret Oppenheim also drew up some designs for sculptures during this period, but did not execute them until much later, for instance "Primeval Venus" (Urzeitvenus), cast in bronze in 1978 on the basis of a drawing and model done in 1933. Meret Oppenheim's first solo show in 1936 took place at the Marguerite Schulthess gallery in Basle with invitations that included a text by Max Ernst. That same year her father was forced to give up his medical practice in Steinen in southern Germany due to difficulties caused by his Jewish name. Although the family was able to move to their summer home in Ticino, Switzerland, Meret's father was not allowed to practice medicine, which left his daughter without financial support.

In Paris, she tried her hand at extravagent designs for jewelry and clothes, typically working out suggestions with no regard for the current fashion code. Nor was she the least interested in aspects of style or the couturier's craft. Instead, she established her own cultural reference——neither timeless, nor ephemeral. The ideas she threw out to the world all conveyed the intimate act of feeling-in-and-with-a-body. A glove, for instance, projects the bones or the veins and blood vessels onto the outermost surface of the hand. The ear harbors a gold bird's nest with an enamelled egg, and a jacket becomes a set table.

At the end of the 30s (she returned to Switzerland in 1939), Meret Oppenheim went through years of crisis during which she continued to work but also destroyed a great many pieces or put them aside unfinished. Having lost her self-confidence, as she said herself, she had to work out new ways of doing what she had previously done "in a state of

innocence." She was shattered by her insight into the dangers to which she would expose herself by relying not on style or repertoire or subject matter, but exclusively on her own sensibility, intuition and knowledge. The latter were, however, sharp instruments in her hands. She applied them incisively, even though her creative energy favored tentative, easy, sparse and gently balanced solutions.

Meret Oppenheim catches us off-guard with subtle traps that reveal her sophisticated sense of baffling and startling insights. She gives us playful glimpses of the night side of things, of their movements and our relationship to them. Meret Oppenheim's playfulness also allows her to roam the range of possibilities inherent in creativity. This is the salient feature of her opus. Each work is created with an unfettered mind and constantly changing methods. A picture may result, for instance, from a combination of control and free flow. Images may be born of energy and speed or of slow enduring tranquillity. The point of departure may be her wish to depict and represent something real or it may be an inner conception directed by her imagination and fantasy. Improvization and conscious combination come into play, as well as ritual repetition.

Meret Oppenheim's creative approach clearly gives precedence to personal content over a quest for form. In her own words: "Every inspiration is born complete with its form. I carry out ideas just the way they come to me. No one knows where inspirations come from, they bring their forms with them; ideas come with their clothes on, like Athena, who sprang from Zeus' head armed and helmeted."

In her works, she fulfills the dream of unified, precisely explored perception and communication. The

desire for "perfect tuning" in her pictorial statements reveals her involvement with extended spatial, temporal and mythical dimensions. Since she flatly rejected any notion of uncontrolled, random association, her works show a certain rigor in contrast to "pure Surrealism."

It was not until 1950, five years after the war, that Meret Oppenheim first returned to Paris. There she met her friends again but was disappointed to find a stagnating spirit and a circle of people around Breton still speaking the same "jargon."

In 1956 she was asked to do a solo show at the Etoile Scellé gallery in Paris. It produced barely a ripple. Apparently her work was "neither abstract nor Surrealist enough" for Paris in the 50s. The explosiveness of her insistence on freedom, her lifelong strategy of avoiding fixation were misinterpreted as uncertainty and relativism. It seems that during the time of crisis, Meret Oppenheim anticipated and suffered from such criticism. It has in fact taken an era of slogans like "Post-Modernism" and "Transavantgarde" in order to discover the relevance of her creative concept. At a time when fundamental systems of cognition are being called into question, "uncertainty" often turns out to be a profound insight into the instability of truth.

Translation: Catherine Schelbert

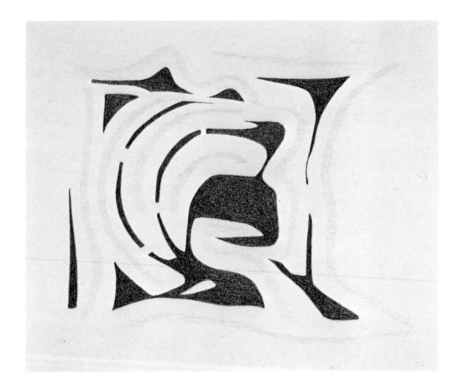

Mountains and Rivers 1974

MERET OPPENHEIM'S POEMS Quick, quick, the most beautiful vowel is voiding.

Meret Oppenheim wrote her first poems in 1933 and continued to write at irregular intervals, often stopping for years, until well into the 1980s. With their combination of graceful guilelessness and severity, the poems, especially those written between 1933 and 1944, rank among the most beautiful lyrical writing of the period, on a par with the work of friends like Kurt Schwitters and Hans Arp. In recent years, the excellence of Meret Oppenheim's poetry has finally met with the acclaim it deserves outside the art world as well, despite the fact that her complete oeuvre comprises a mere total of 39 poems. The publication of her collected poetry in 1984 by Suhrkamp Verlag* in Frankfurt——one of the most venerable and prestigious publishers of German literature—— attracted the critical attention of prominent literary scholars as shown by the positive response in European feuilletons. Since then, the significance of Meret Oppenheim's contribution to literature has been recognized by anthologies and this, in turn, has led to an inner exchange between writers today and Meret Oppenheim's contemporaries.

The titles of Meret Oppenheim's pictures express a profound yearning for language, for words that are charged with the task of riding into the picture from all four corners at once and joining in the dialogue. Conversely, her poems convey a concerted drive towards fulfillment in the image, an impulse towards volume and extension. This drive is enhanced in Meret Oppenheim's early, Dadaist poems by a vehement, in fact obstinate, but always strict rhythm. The present selection of five poems dates from these early years.

I find it appealing and appropriate to speak of autobiographically derived works, something like "indirect speech" with intensely visual features. But there is also a cosmic, philosophical shimmer to all of Meret Oppenheim's work——her poems, her sculptures, her pictures. The outlook of the "artist" Meret Oppenheim is inescapable in everything she wrote: the look with which the most beautiful words are "lost," the look through which "the most beautiful vowels are voided."

Even in these early poems, Meret Oppenheim's personal attitude as an artist is unmistakably manifest. For instance, "Sansibar", a poem of 1933, is almost like a draft of her later, now famous "Fur Street" as if she had planted the seeds of her later, enduring fur-cup renown:

> Little red vixen
> All live in loneliness
> They endure the longest
> They eat their fur

Those who eat their fur endure the longest, as Meret Oppenheim says in her poem. This includes people who are able to take leave of themselves. We must shed our outer covering (in this case, fur) in order to survive, to endure.

Christine Meyer-Thoss
January, 1988

*Meret Oppenheim: "Husch, husch, der schönste vokal entleert sich. Gedichte, Zeichnungen", Edition Surhrkamp, Frankfurt, 1984. Edited by Christiane Meyer-Thoss with a detailed afterword.

Translation: Catherine Schelbert

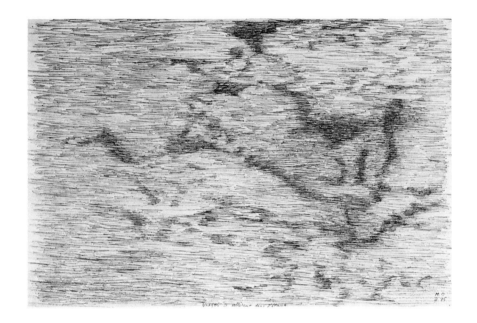

14
Sky Reflecting in Water 1975

Kacherache, panache,
Praise be the timid Wallach.
Slowly he nears——comes or doesn't come.
But one thing is certain. It is
good form to overlook him.

I know him.
He reaches out to shake hands and does not pull
back although his hand stinks. On the street
he bites your calf.
To the Queen of England he gave a
handkerchief.

We want to weave straw chairs for life. 1933

A curious part of the planet
Wrapped in white cloth
Rolls down the winding
Stairs of a house
It is rolled (ceremony)
Down the
Winding stairs of a house
Powdery unseen it remains on the street
 A bright relief at night
 Laborious
Like a mountainous landscape. 1933

One feeds on berries
One admires with the shoe
Quick, quick, the most beautiful vowel is voiding. 1936

Loyal Captain
Tell me
Show me the spot in the clouds
That the wings of the swallow opened
The valley of waves in the goddess's hair
The green lights in the forest.

Here it is night——
Evil brooms kill kobolds
No wheel turns anymore.

Darkness knows itself not
Nor does it ask
It is a fist within a fist
That no one sees. 1944

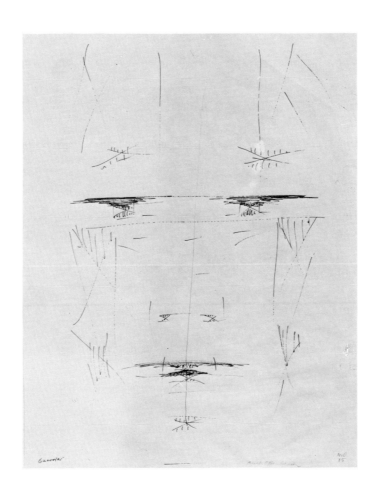

My Friend's Dog

I love my friend's
dog. He can say "yes" so
beautifully. He can say "yes"
when you forget him. He condemns
no one that compares himself to him.
Wherever he goes, spring goes
too. When he weeps, nature
loses its feathers. But when he's
in a good mood, he skillfully pushes
your hand to his mouth to hear
its greatest secrets.
Like every brave man he has
two souls in each breast,
twenty-five in hands and feet. 1944

Poetry translation: Catherine Schelbert

PLATES

3
Night Sky with Black Clouds 1946

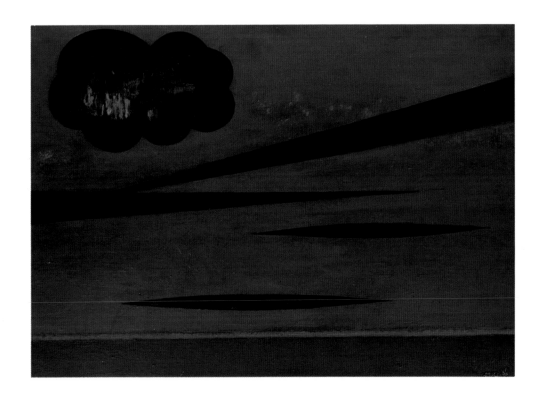

4
Genoveva Floating Over the Water 1957

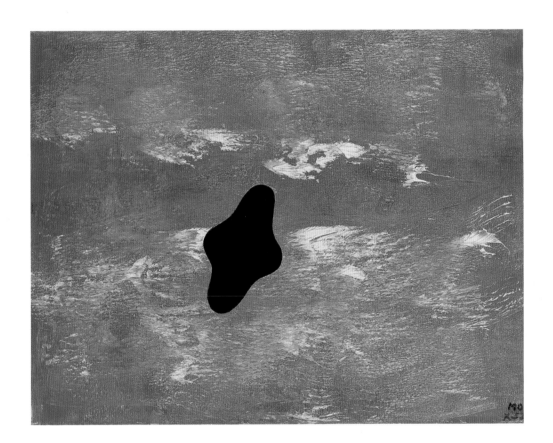

5

The Brownies are Leaving the House 1961

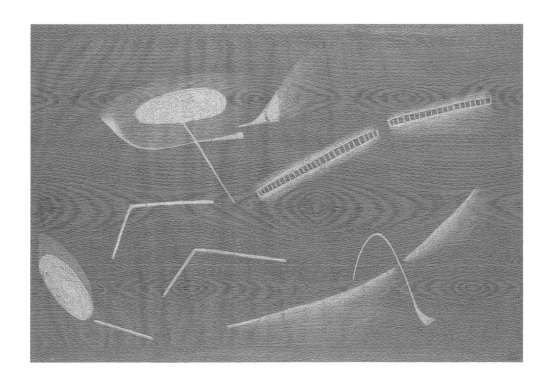

8
Bon Appetit, Marcel 1966

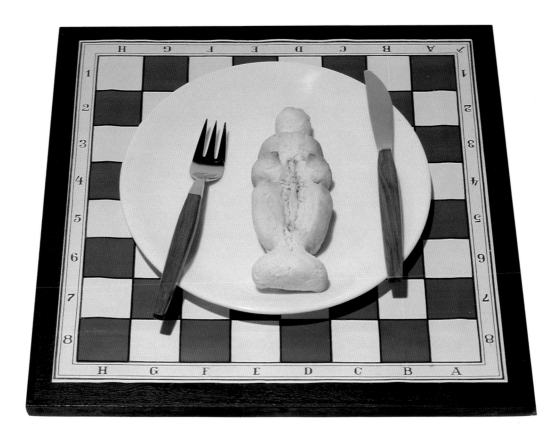

11
Suns Over Little Alpine Mountains 1970

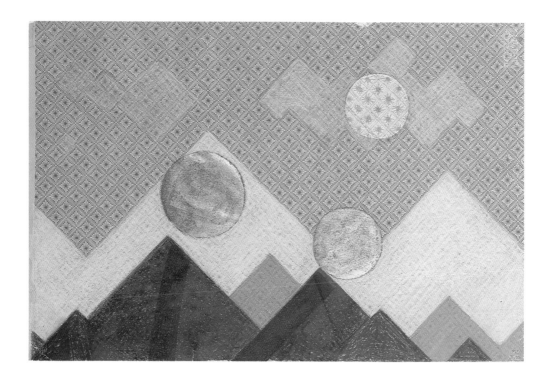

13
Hazy Flower 1974

15
There She Flies, the Beloved One 1975

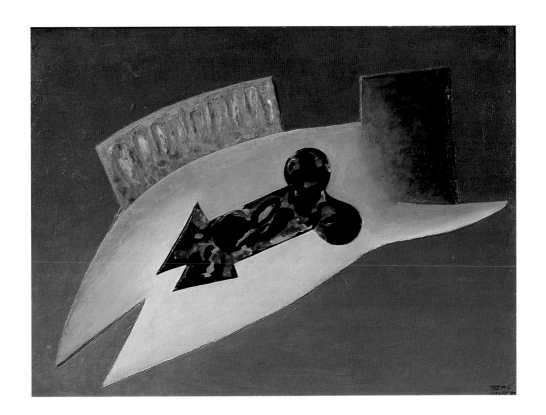

16
River in the Jungle with a Boat Made of a Trunk or a Crocodile 1975

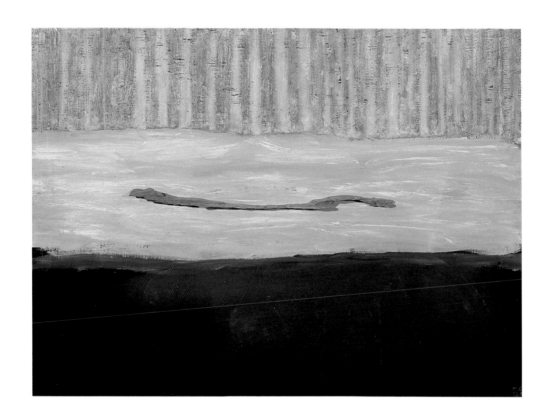

17
A Moon in Light Red and Cypresses in Front of a Black Sky 1975

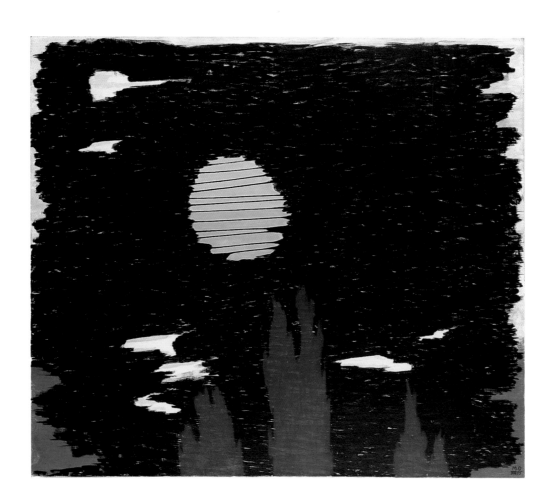

19
Lilly of the Sea 1977

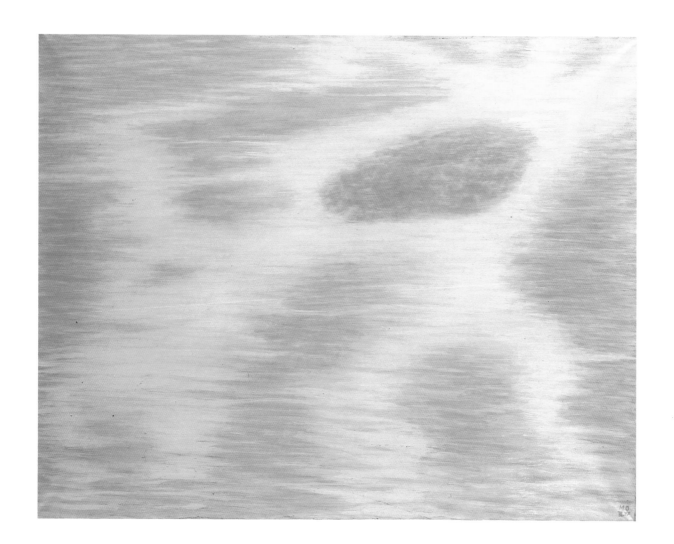

21
The Feelings for Art 1979

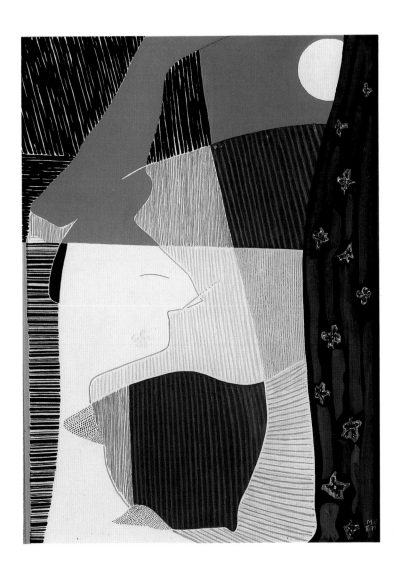

24
An Agreeable Moment on a Planet 1981

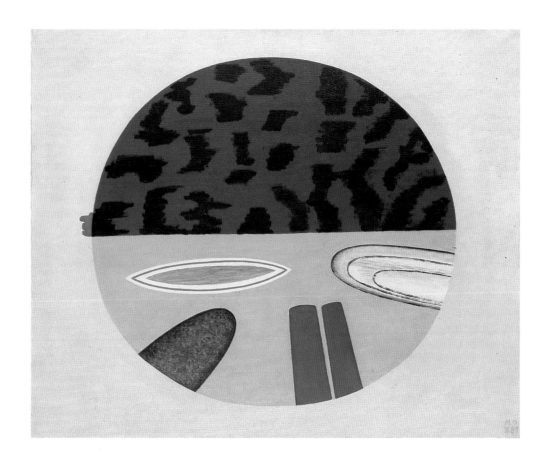

WORKS IN THE EXHIBITION

Measurements are Height x Width x Depth. Following the titles in parentheses are the catalogue raisonné numbers from the 1982 monograph on Meret Oppenheim by Dominique Burgi and Bice Curiger.

1 illustrated p. 8
Woman with Naked Upper Part of the Body. Man with Balance Over the Ear. Two Ghosts (A15)
FRAU MIT NACKTEM OBERKORPER. MANN MIT WAAGE UBERM OHR. ZWEI GESPENSTER
1934
Ink on paper
8¼ x 10⅝ in/21 x 27 cm

2
Woman in Stone (B11)
STEINFRAU
1937
Crayon on paper
6½ x 6⅞ in/16.5 x 17.5 cm

3 illustrated p. 23
Night Sky with Black Clouds (C15a)
NACHTHIMMEL MIT SCHWARZEN WOLKEN
1946
Oil on pavatex
19¾ x 27½ in/50 x 70 cm

4 illustrated p. 25
Genoveva Floating Over the Water (F17)
GENOVEVA UBER DEM WASSER SCHWEBEND
1957
Oil on pavatex
14⅜ x 18½ in/36.5 x 47 cm

5 illustrated p. 27
The Brownies are Leaving the House (K35)
DIE HEINZELMANNCHEN VERLASSEN DAS HAUS
1961
Oil crayon on paper
21¼ x 31½ in/54 x 80 cm

6
Table in Heaven (L55b)
TISCH IM HIMMEL
1962
Pencil on paper
10¼ x 12⅞ in/26 x 32.5 cm

7
Still Life with Fruit (N98)
STILLEBEN MIT FRUCHTEN
1964
Oil on pavatex
31½ x 20½ in/80 x 52 cm

8 illustrated p. 29
Bon Appetit. Marcel! (P109)
DIE WESSE KONIGIN
1966
Mixed media
14 x 14 x 2 in/35.6 x 35.6 x 5.1 cm

9
The Eye of Mona Lisa (Q121)
DAS AUGE DER MONA LISA
1967
Oil on canvas
9 x 12⅝ in/23 x 32 cm

10
Something Underneath a Haystack (S132d)
ETWAS UNTER EINEM HEUHAUFEN
1969
Colored pencil on paper
10¼ x 13⅜ in/26 x 34 cm

11 illustrated p. 31
Suns Over Little Alpine Mountains (T135a)
SONNEN UBER ALPENBERGLEIN
1970
Oil crayon on Italian bookbinding paper
13 x 19⅜ in/33 x 49 cm

12 illustrated p. 12
Mountains and Rivers (X222)
BERGE UND FLUSSE
1974
Pencil on paper
19¾ x 24 in/50 x 61 cm

13 illustrated p. 33
Hazy Flower (X246)
NEBELBLUME
1974
Oil on canvas
76¾ x 51¼ in/195 x 130 cm

14 illustrated p. 14
Sky Reflecting in Water (Y249)
HIMMEL, DER SICH IM WASSER
WIDERSPIEGELT
1975
Pencil and ball point pen on paper
12⅝ x 19⅛ in/32 x 48.5 cm

15 illustrated p. 35
There She Flies, the Beloved One (Y266a)
DORT FLIEGT SIE, DIE GELIEBTE
1975
Rugosit-relief on plastic panel painted
with oil color 28 x 39 in/71 x 99 cm

16 illustrated p. 37
River in the Jungle with a Boat Made of a
Trunk or a Crocodile (Y268)
DSCHUNGELFLUSS MIT
EINBAUM ODER KROKODIL
1975
Oil on canvas with worm-eaten wood
25¼ x 34⅝ in/64 x 88 cm

17 illustrated p. 39
A Moon in Light Red and Cypresses
in Front of a Black Sky (Y274a)
ROTLICHER MOND UND
ZYPRESSEN VOR SCHWARZEM
HIMMEL
1975
Oil on canvas
31⅞ x 37 in/81 x 94 cm

18 illustrated p. 17
Warrior (Y275)
KRIEGER
1975
Ink on paper
$16\frac{1}{8}$ x 13 in/41 x 33 cm

19 illustrated p. 41
Lily of the Sea (AA30)
MEERLILIE
1977
Oil on canvas
$44\frac{7}{8}$ x $57\frac{1}{2}$ in/114 x 146 cm

20
A Proud Cock (AA53)
EIN STOLZER HAHN
1977
Collage
$12\frac{5}{8}$ x $9\frac{3}{8}$ in/32 x 24 cm

21 illustrated p. 43
The Feelings for Art (AC91)
DIE LIEBE ZUR KUNST
1979
Gouache
26 x $18\frac{7}{8}$ in/66 x 48 cm

22
White Bird Over Water (AD106a)
WEISSER VOGEL UBER WASSER
1980
Gouache and oil crayon
5 x $19\frac{3}{4}$ in/12.5 x 50 cm

23
Sun Over a Shore with Eggs (AE118)
SONNE UBER STRAND MIT EIERN
1981
Gouache and colored crayon on paper
$9\frac{3}{8}$ x $11\frac{7}{8}$ in/23.5 x 30 cm

24 illustrated p. 45
An Agreeable Moment on a Planet (AE135)
EIN ANGENEHMER MOMENT AUF
EINEM PLANETEN
1981
Oil on canvas
32 x $39\frac{3}{8}$ in/81 x 100 cm

25
Table with Birdlegs (B8)
TISCH MIT VOGELFUSSEN
1983 (original in 1939)
Wood with goldleaf. Cast bronze. 1/30
$26\frac{1}{4}$ x $20\frac{1}{2}$ x $24\frac{3}{4}$ in/66.7 x 52.1 x 62.9 cm

26
Rome Under the Earth (A115)
ROMA UNTERIRDISCH
1985
Oil crayon on paper
$14\frac{1}{4}$ x $19\frac{3}{4}$ in/36 x 50 cm

CHRONOLOGY

1913 Born in Berlin-Charlottenburg as daughter of a German father and Swiss mother. Meret Oppenheim's father is a physician, she spends her youth in the Bernese part of Canton Jura, in southern Germany and in Basle.

1930 Still a student, she makes a collage "A schoolgirl's exercise-book", which is published in 1957 in the magazine "Le Surréalisme même".

1931 M. O. decides to become a painter and leaves high school. In Basle she meets the painters Walter Kurt Wiemken and Irène Zurkinden.

1932 At the age of 18 years she moves to Paris. Sporadic attendance of the "Académie de la Grande Chaumière", but she prefers to work by herself. She makes poems and drawings partly with glued objects on top, and the design for the project "Someone observes someone's dying" which becomes the later executed sculpture "Le spectateur vert" (painted wood and copper, 1959, Kunstmuseum Berne, and in serpentine, 1976, Wilhelm-Lehmbruck Museum, Duisburg, FRG).

1933 Alberto Giacometti and Hans Arp visit M. O. in her studio and invite her to exhibit together with the Surrealists in the "Salon des Surindépendants". She frequents the circle around André Breton in Café de la Place Blanche. Until 1937 she participates in the group's exhibitions.

1936 The object "Le déjeuner en fourrure" is acquired by Alfred Barr Jr. for the Museum of Modern Art in New York. In the same year she has her first one-person show in the Gallery Schulthess in Basle. Max Ernst writes a text for the invitation card. The object "Ma gouvernante, my nurse, mein Kindermädchen", which was to be seen in this exhibit is now in the Moderna Museet in Stockholm. M. O. tries to earn money with designs for modern jewelry. During the war she learns the restoration of paintings for the same reason.

1937 M. O. returns to Basle and for 2 years attends the School of Arts and Crafts there. This is the beginning of a crisis which is to last 18 years, during which M. O. continues to work but destroys many pieces or leaves them aside unfinished. She entertains contacts with the "Group 33", takes part in exhibitions of the Swiss Artists Association "Allianz".

1938 A trip with Leonor Fini and André Pieyre de Mandiargues through Upper Italy.

1939 M. O. is staying once again in Paris. She takes part in an exhibition of fantastic furniture along with Max Ernst, Leonor Fini and others in the Galerie René Drouin in Leo Castelli in Paris, submitting objects and a table with bird's feet.

1943 The picture "War and Peace" is bought by the Kunstmuseum Basle.

1945/49 M. O. becomes acquainted with Wolfgang La Roche, whom she marries and lives with from then on in Berne, Thun and Oberhofen. M. O. finds access to the artist scene in

Berne. An important middleman and stimulating friend is the director of the Kunsthalle, Arnold Rüdlinger.

1950 M. O. is in Paris again for the first time after ten years; she meets friends from the thirties, but at the same time she is disappointed how much they are persevering "in a jargon."

1954 M. O. moves into a studio in Berne; her crisis is over.

1956 She designs costumes and masks for Daniel Spoerri's staging of Picasso's "How one grabs wishes by the tail", which is produced in the Theatre of the Lower City in Berne. For the exhibition on view at the same time she creates the object "Le couple."

1959 M. O. organizes a spring banquet which is presented on the body of a nude woman. This takes place in Berne and is attended by a small circle of close friends——three couples, including the woman on the table. Breton urges her to repeat the "Feast" in Paris on the occasion of an exhibit taking place a few months later "Exposition InteR natiOnale du Surréalisme" in the Galerie Cordier. This was the last joint exhibition of the Surrealist group. In the following years she has many one-person exhibits and takes part in group exhibits too, among others in Basle, Paris, Milan, New York, Zurich, Berne, Stockholm, Oslo, Geneva.

1967 Retrospective exhibition at the Moderna Museet in Stockholm. In December her husband Wolfgang La Roche dies. M. O. moves to Berne into a flat with a studio, and in addition rents a studio in Paris from 1972 on.

1974/75 Retrospective exhibition travels to the museums of Solothurn, Winterthur and Duisburg.

1975 M. O. receives on January 16th the Art Award of the City of Basle. She makes a speech which receives wide notice, in which she defines her position regarding the problem of "the woman artist."

1981 In Basle, in the Edition Fanal appears a publication of poems (1933–57) and silk-screen prints with the title "Sansibar."

1982 M. O. receives the Great Prize of the City of Berlin. She is invited to take part in Documenta 7 in Kassel. Meret Oppenheim lives and works in Berne and Paris.

1982 Monograph by Bice Curiger with catalogue raisonné by Meret Oppenheim and Dominique Burgi.

1983/84 Retrospective exhibition travels to Genoa, Milan and Naples.

1984 Retrospective exhibition at the Kunsthalle, Berne.

1986 November 15th, M. O. dies in Basle.

1987 Exhibition of the works given by M. O. to the Kunstmuseum, Berne. Memorial exhibitions at the Galerie Renée Ziegler in Zurich and Galerie Thomas Levy in Hamburg.

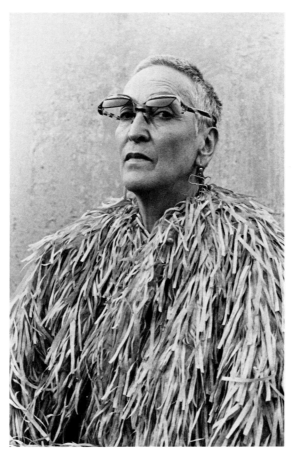

Photograph: Claude Lê-Anh

Special thanks to The Estate of Meret Oppenheim and Galerie Renée Ziegler, Zurich for their invaluable assistance.

Catalogue © 1988. Kent Fine Art, Inc. Douglas Walla, Susan Harris, Denise Del Priore, Eileen Costello, Bruce Dow, Jeanne Marie Wasilik, Anna Lundgren, Daniel Berlin.

Catalogue design by Marcus Ratliff, New York. Printed by Becker Graphics, New York.